ART for ALL

Why Make Art?

Elizabeth Newbery

Chrysalis Children's Books

First published in Great Britain in 2001 by
Ⓒ Chrysalis Children's Books
An imprint of Chrysalis Books Group Plc
The Chrysalis Building, Bramley Rd, London W10 6SP
Paperback edition first published in 2004

For Eleanor Demaus

Editor: Claire Edwards
Designer: Jane Horne
Picture researcher: Diana Morris
Consultant: Anthea Peppin
Education consultant: Sue Lacey
Proof reader: Kate Phelps

ISBN 1 84138 199 3 (hb)
ISBN 1 84138 857 2 (pb)

British Library Cataloguing in Publication Data for
this book is available from the British Library.

Printed in Hong Kong
10 9 8 7 6 5 4 3 2 1 (hb)
10 9 8 7 6 5 4 3 2 1 (pb)

Picture acknowledgements
Cover:
Bode-Museum, Berlin/Bridgeman Art Library: front cover cr. British
Museum/Bridgeman Art Library: front cover br. Kevin Miller/Stone: front
cover l. National Gallery, Oslo/Bridgeman Art Gallery: front cover c.
© 2001 DC Comics: back cover.
Inside:
AKG London: 19b. J.G. Berizzi/RMN: 9br. Bode-Museum,
Berlin/Bridgeman Art Library: 22bl, 28tr. Boymans van Beuningen
Rotterdam /Francis B Mayer/Corbis: 17bl © DACS London 2001.
British Museum/Bridgeman Art Library: 7t. Bury Art Gallery & Museum,
Lancs/Bridgeman Art Library: 5br. Rogers, Coleridge & White: 25c © the
artist. © 2000 Cordon Art-Baarn-Holland. All rights reserved: 25br.
David Cumming/Eye Ubiquitous: 27br. Shirley Day, London/Werner Forman
Archive: 16tr. © 2001 DC Comics Inc: 7br. Eleanor Demaus: 4c. Dreweatt
Neale Fine Art Auctioneers, Newberry/Bridgeman Art Library: 9tr.
Fitzwilliam Museum, Cambridge/Bridgeman Art Library: 3, 13c. Werner
Forman Archive: 23cr. Sonia Halliday & Laura Lushington: 2, 6cl.
Béatrice Hatala/ RMN: 26bl © Sucession Picasso/DACS London 2001.
Ex-Edward James Foundation, Sussex/Bridgeman Art Library: 21br © DACS
London 2001. Photograph © Mauritshuis, The Hague, In no 575: 12br.
Kevin Miller/Stone: 9l. Photo © MOMA NY: 24b © Pro Literis
Zurich/DACS London 2001. Photo © MOMA NY. Gift of Edward M M
Warburg: 25t © DACS London 2001. Museum of City of New
York/Bridgeman Art Library: 19t. National Gallery, Oslo/Bridgeman Art
Library: 16bl © DACS London 2001. National Gallery of Victoria,
Melbourne/Bridgeman Art Library: 6br. National Portrait Gallery, London:
11tl © DACS London 2001. Natural History Museum, London: 18b. Erica
Newbery: 4-5, 29t. © Nike Inc: 5cl. PowerstockZefa: 23t. Private
Collection/Bonhams, London/Bridgeman Art Library: 23bl. The Prado,
Madrid/Bridgeman Art Library: 8bl, 14c. Private Collection/Bridgeman Art
Library: 1, 15t, 20b, 28bl, 29br. Private Collection/Giraudon/Bridgeman Art
Library: 17tr. Private Collection/Bridgeman Art Library: 26-7c © Claes
Oldenburg. Royal Holloway & Bedford New College, Surrey/Bridgeman Art
Library: 15b. The Royal Institution of Cornwall, Royal Cornwall Museum,
Truro: 11br. Ferdinando Scianna/Magnum Photos: 10b. Courtesy of Carl
Solway Gallery, Cincinnati, Ohio. Photo Chris Gomien: 27t © the artist.
Superstock: 13tl © Dale Kennington/VAGA/DACS London 2001. Tate
Picture Library, London: 21t, 21cr detail.
Every attempt has been made to clear copyrights but should there be
inadvertent omissions please apply to the publisher for rectification.

Some of the more unfamiliar words used in this book are explained in the glossary on pages 30 and 31.

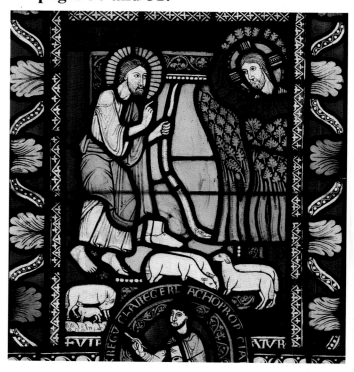

Contents

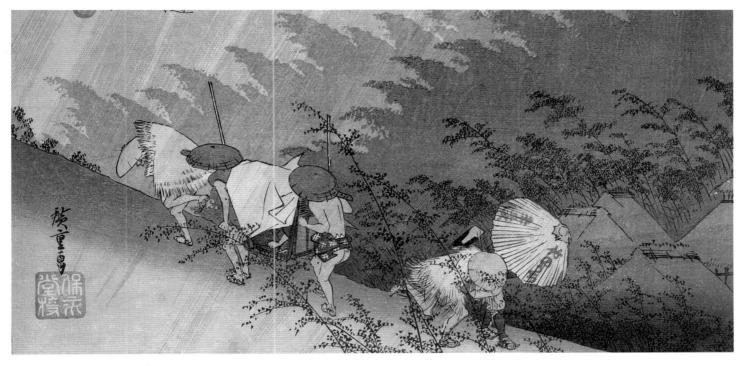

Have you ever wondered why we make art? Most of us can use words to say exactly what we want – but have you ever felt that you need to use something else? Over time, people across the world have made art instead of using words for many different reasons.

Art

Some artists use paintings or carvings to tell stories about the past or the future. Others may record scenes from everyday life or show important events. Posters are often used to persuade us to do or buy things. Many artists use art to express a point of view or to make us look at things in a different way. They are able to paint things that make us feel happy or sad.

Others use drawing to help them understand the world around them. So, whenever you see an image, remember there's a reason for it.

▲ *A pond with ducks, birds and the sun*
Young children start to draw and paint as they learn to speak.
They can often use art to explain what they're thinking, feeling and seeing before they have learnt the words to do so.

▼ Graffiti, Manchester, England, 1999
In most cities you can see graffiti sprayed on walls. It is usually made by young people who want to mark their area with names, signs and comments about what is happening around them.

for all

▼ The Random Shot by Sir Edwin Landseer, 1848
This picture was painted for Prince Albert, husband of Queen Victoria. It shows a dying deer lying in the snow and her baby who tries to drink her milk. It illustrates a verse from the poem *The Lord of the Isles* by Sir Walter Scott that was very popular in Victorian times. How does this picture make you feel? Sad or happy?

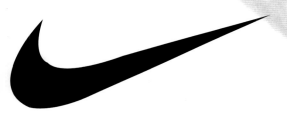

▲ Nike 'swoosh' symbol
Advertisers know that pictures and symbols can be very powerful indeed. Nike was the Ancient Greek goddess of victory. The shape of the logo suggests speed and movement. It has become known to people all over the world, so no words are needed to say what it is!

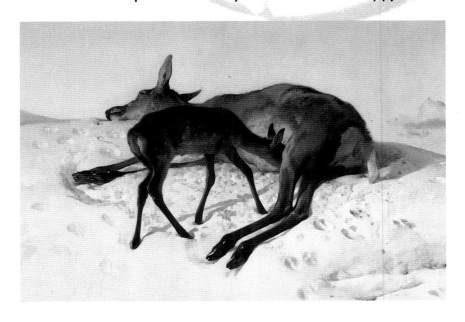

If you want to read or to listen to a story you probably look for a book, a tape or a CD. But not every story needs words. All kinds of art – paintings, pots, carvings, sculpture, tapestries, metalwork, drawings and prints – can tell a story too.

Draw me

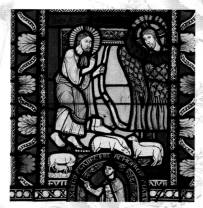

The Ancient Greeks liked stories about myths and legends, so they decorated pots with pictures of them. The Romans told stories about great emperors by carving them in stone and displaying them in places where everyone could see them. In the Middle Ages, people in Europe learnt about Bible stories from pictures made of brightly-coloured stained glass set into enormous church windows (see above). Today, all sorts of people enjoy following adventure stories as pictures in comics.

▶ *Greek amphora, made about 540 BC*
Amphoras were pots used in Ancient Greece for holding wine or oil. This amphora is decorated with a scene from the legend of the Trojan Wars, in which the Greeks fought against the Trojans. Achilles was the greatest Greek warrior. This picture shows him killing a Trojan with a spear.

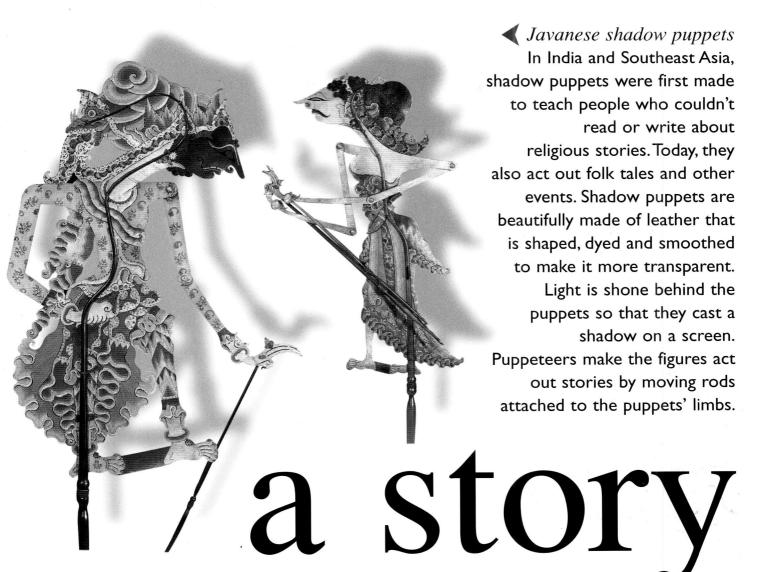

◄ Javanese shadow puppets
In India and Southeast Asia, shadow puppets were first made to teach people who couldn't read or write about religious stories. Today, they also act out folk tales and other events. Shadow puppets are beautifully made of leather that is shaped, dyed and smoothed to make it more transparent. Light is shone behind the puppets so that they cast a shadow on a screen. Puppeteers make the figures act out stories by moving rods attached to the puppets' limbs.

a story

▶ Superman

Superman was created by two cartoonists in 1938. His adventures are set in America where he fights a full-time battle saving people and the country from evil forces. The figures in the pictures are always very active so that you can understand the story without too many words.

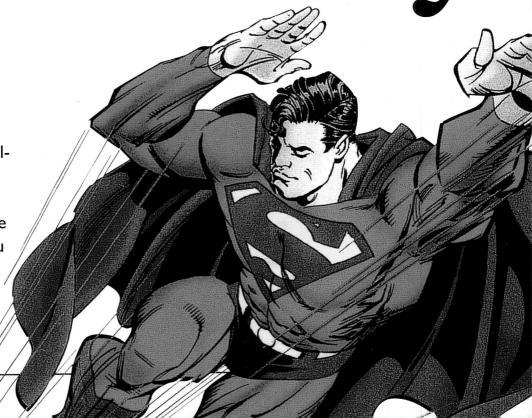

Some of the oldest images in the world were made by people to express their religion and beliefs. Many pictures teach people about God or gods. Other images are linked to spirits and superstition. Some societies have used art to bring about magic.

Gods and

The oldest paintings in the world are found in caves where religious ceremonies probably took place. The Ancient Egyptians painted human eyes on coffins so that the dead could see in the Next World. North American Indian shamans carved scary faces on rattles to frighten bad spirits away. In many parts of the world people still make carvings, masks and objects so that they can perform religious ceremonies.

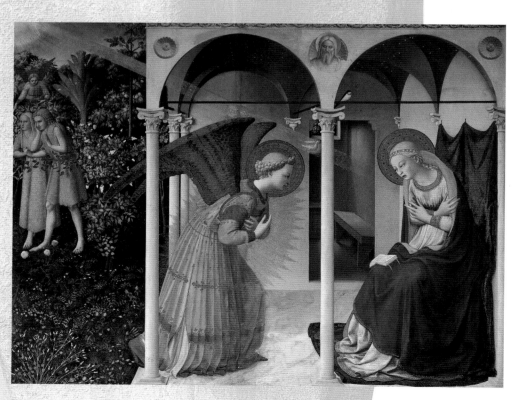

◀ *The Annunciation by Fra Angelico, fifteenth century*
Fra Angelico was a friar who lived in a monastery in Italy. He painted religious pictures on wood panels and also frescos straight on to the walls of churches and other Christian buildings. He wanted to help people think about God and pray. This scene shows the Angel Gabriel telling Mary that she will be the mother of Jesus.

Prayer rug from Persia (now Iran) ▶

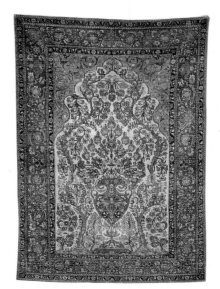

Muslim prayer rugs are put down in mosques, houses and outside so that people have a clean place where they can worship. Muslim religious law forbids people to make pictures of living creatures, so works of art are made with patterns or lettering instead. This prayer rug, made for a rich Muslim, is decorated with a vase of flowers, leaves and trees.

spirits

◀ *Totem pole from the west coast of Canada*

North American Indians carve totem poles as reminders of dead people or as sacred signs of a family or tribe. The carvings (called totems) represent the spirits of dead people and take the shape of natural things such as birds, animals or humans.

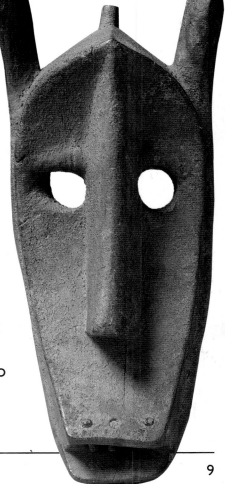

▶*Lion mask from Mali, West Africa*

In Africa, lions are seen as strong and noble. When African rulers wore this mask, they were said to take on the spirit of the lion and became more powerful.

Images of real people are called portraits. Some portraits are specially commissioned – often to make men and women appear more beautiful, important or powerful. Many are painted to honour explorers or inventors or other famous people. Artists sometimes painted miniature portraits of loved ones that could be carried around.

People in art

Before modern communication, rulers had to control lots of people in distant places without the help of television, radio or the Internet. One way they could remind people who was boss was by putting their face on coins, or by putting up statues and portraits of themselves for everyone to see. Today people still commission portraits, but they may be photographs as well as paintings and statues.

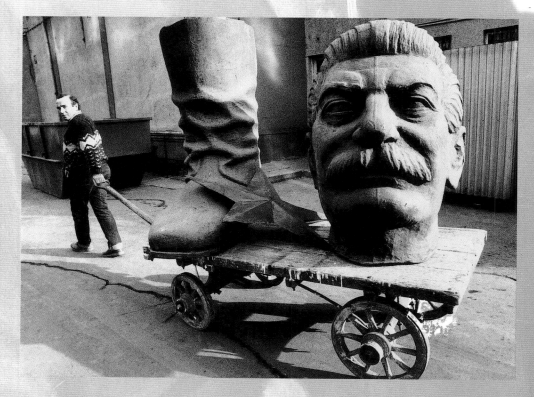

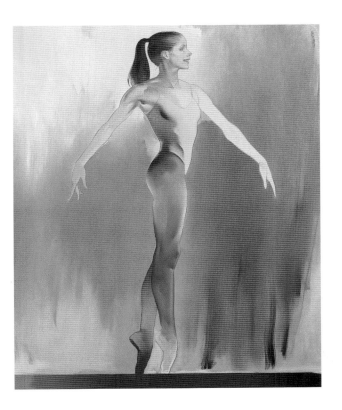

▲ *Darcey Andrea Bussell by Allen Jones, 1994*

Darcey Bussell is an internationally famous and beautiful ballerina. She liked this portrait, but she thought it made her look more like an Olympic swimmer than a ballerina. The artist has concentrated on the ballerina's body rather than on her face. Do you think it tells us more about her than her face alone could do?

◄ *Joseph Stalin*

Joseph Stalin was the leader of the Russian Communist Party from 1922 to 1953. He was a dictator who ruled with great cruelty. While he was leader, Stalin ordered many statues of himself to be built, but after he died they were all pulled down. This photograph shows part of a huge statue of Stalin that is being broken up and carted away. The sculptor made Stalin look very powerful. Look at the photograph. Does Stalin look so important now?

▼ *Black John of Tetcott by an unknown artist*

Black John was a jester who lived in England in the eighteenth century. He was a hunchback and less than four feet tall. People said that Black John could remove the feathers of sparrows with his lips and bring up strings of live mice from his stomach! This painting was commissioned by Black John's master John Arscott. The two were devoted to each other, and Black John died of grief soon after his master's death in 1788.

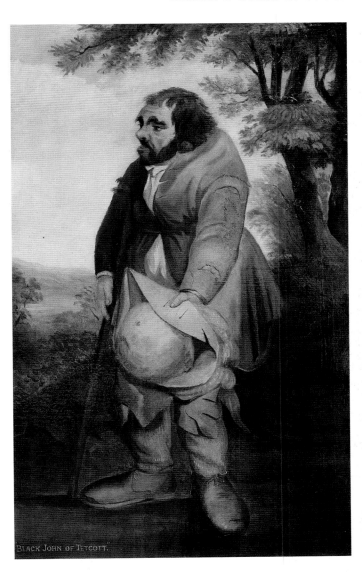

BLACK JOHN OF TETCOTT.

A lot of art is about important people, places, stories or events. But many artists like to draw what is going on around them. They show scenes of ordinary life in the home, at work, in the countryside, or in busy cities.

Everyday

Until about 300 years ago, most paintings were about grand subjects such as battles, religion and court life. The pictures were often very large. Only rulers and nobles had space for them, enough money to buy them and enough education to understand them. As more people became better educated and had more money, they wanted pictures too. So artists painted about everyday life that everybody could understand. Many of these pictures became best sellers.

▶ *Smell by Jan Miense Molenaer, about 1637*
This painting is one of five about the senses (sight, sound, touch, taste and smell). The senses were a popular subject for paintings. Artists usually showed smell as sweet-smelling flowers. In this down-to-earth painting the father holds his nose while the mother wipes the baby's dirty bottom with a cloth. Pictures like these cost very little at the time but today they are very valuable.

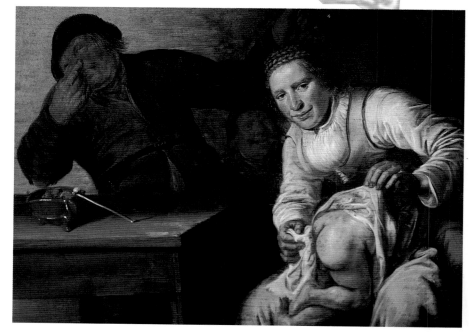

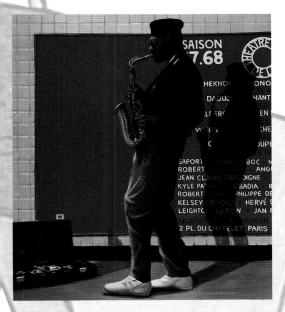

The Concert by Dale Kennington
This painting shows a busker playing the saxophone. The artist has included the case the busker has put out to catch money. The painting looks very lifelike, but do you think the artist has left out any details?

life

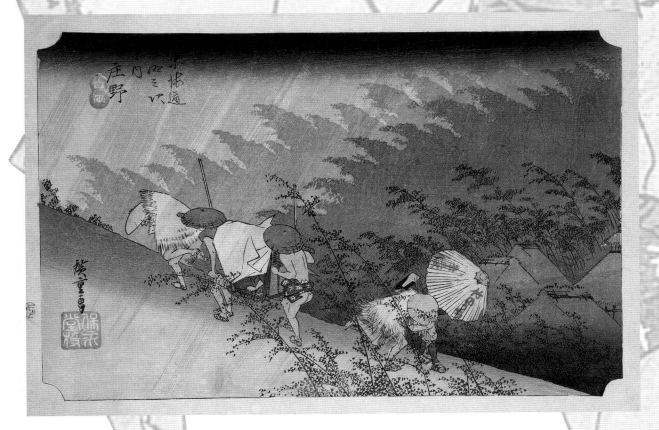

▲ *Sudden Rainstorm by Ando Hiroshige, 1833*
Ando Hiroshige was a Japanese painter and printmaker, famous for his pictures of ordinary people set in the beautiful countryside of Japan. He made lots of prints after travelling along the Tokaido, a great highway on the Japanese island of Honshu. This one shows Japanese peasants scurrying for shelter from a heavy downpour of rain.

Have you ever seen an advert for a chocolate bar and thought that you must have one NOW? Or looked at a poster for a film or an event and longed to see it?

Get the

Images put powerful messages across much more directly than words can. So art has often been used to persuade us to buy, do and think things – for good and bad reasons. For instance in wartime, governments send out propaganda posters. They use propaganda to warn people about an enemy or persuade them to help their country. Some artists make works of art to draw our attention to important matters such as injustice, or the horror of war. Other artists try to shock us into thinking about matters we would prefer to avoid.

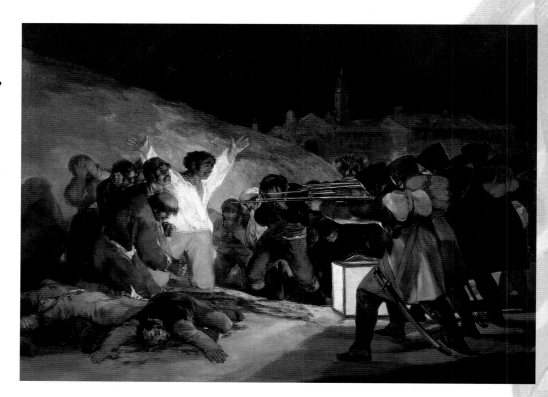

▲ *Execution of the Defenders of Madrid, 3rd May 1808 by Francisco Goya, 1814*
Goya was the official painter to the Spanish royal family. In 1808 France invaded Spain and replaced the Spanish king with a French ruler. Many Spanish people rebelled but they were no match for the French troops. On 3 May 1808, rebels were rounded up and executed. Goya painted this picture after the war had ended. Do you think he supported the Spanish or the French during the war?

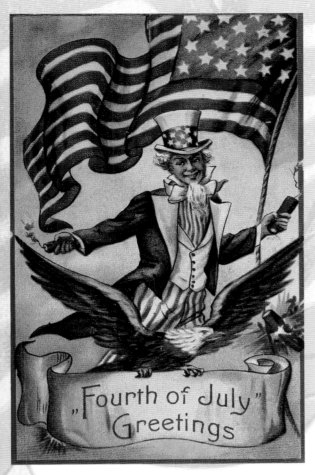

Uncle Sam postcard, nineteenth century
Uncle Sam was the name and character that developed from US – the initials for the United States. The cartoon figure nearly always has a beard and wears a top hat. Here, Uncle Sam illustrates a postcard celebrating 4 July, which is American Independence Day. This day marks the date when America became an independent country, no longer ruled from Britain. The poster design also includes the American flag and the eagle, which is the symbol of America. All three images send out messages of great national pride.

message!

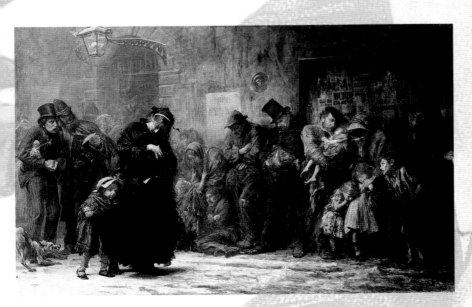

Applicants for Admission to a Casual Ward by Sir Luke Fildes, 1874
This painting shows homeless people in Victorian times. They are waiting for tickets to the workhouse where they will be able to sleep for the night. The painting was put up in a London college to show the students how miserable life was for people without homes.

Artists can create feelings and mood in their work. By choosing particular colours and making us view things in certain ways, they can also make us feel happy, angry or confused.

In the

These images make us react in very different ways. How have the artists done this? Like a cartoonist, the maker of the mask has used strong lines to make an angry expression. Edvard Munch has used swirling lines and strong colours to create a sense of confusion and panic. Mary Cassatt has used soft-coloured, powdery pastels to give the drawing a gentle feel. Oskar Kokoschka used bright colours, thick paint and broad brush strokes to make the mandrill look excitable.

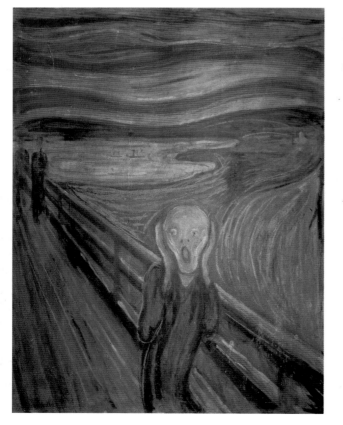

◀ *The Scream by Edvard Munch, 1893*
This is what the artist, Edvard Munch, said about this painting, 'Suddenly the sky became a bloody red. I stopped and leaned against the railing, dead tired, and I looked at the flaming clouds that hung like blood over the blue-black fjord and the city. My friends walked on. I stood there, trembling with fright. And I felt a loud unending scream piercing nature.' Do you think the picture matches the words?

◄ Japanese Noh mask
In films or the theatre, actors usually use make-up to change their features. In Japanese Noh plays (pronounced 'no'), actors change their characters by wearing special masks.

Mother and Child by Mary Cassatt, about 1890 ►
Mary Cassatt was an American artist who spent most of her life in Paris. Many of her drawings and paintings were of mothers and children and the special feelings between them.

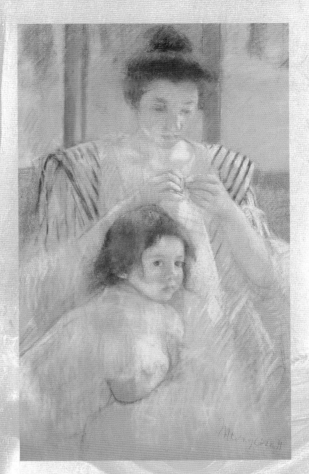

mood

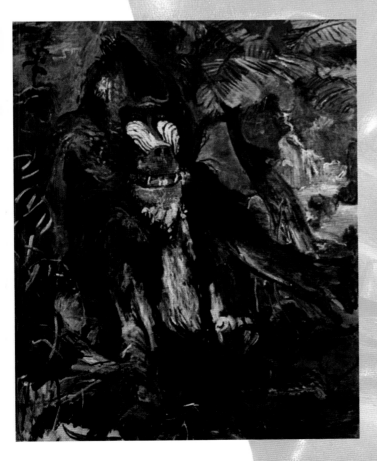

◄ The Mandrill by Oskar Kokoschka, 1926
Mandrills are a type of ape that live in West Africa. They have red noses, blue bottoms and are covered in shaggy yellow-brown hair. Apes often get very excitable, swinging swiftly from branch to branch and screeching loudly. Oskar Kokoschka painted this mandrill in London Zoo.
Do you think it is grinning menacingly because it didn't like being watched and painted? Or do you think it is grinning because it liked the attention?

How do you learn about news events and places? If you want to find out more information, you probably read a newspaper or reference book, watch television or surf the Internet.

Recording

Before photography and other modern technology was invented, words and sketches were the only way to report and record important events. Artists and reporters went with armies into war to record battles. They travelled with explorers to make maps, sketches and reports of the things they found. These were used instead of photographs in newspapers and magazines. The name given to the art of drawing an event as it happens is reportage. Official war artists are still used in wartime, but photographers cover the main stories.

▶ *Springhare by Georg Forster, 1772–1775*
In 1772 Captain James Cook, a British explorer, set off to sail round the Antarctic. On the way, he discovered many islands in the South Pacific Ocean. Captain Cook took several artists and scientists with him to make detailed drawings of the plants, birds and animals they found.

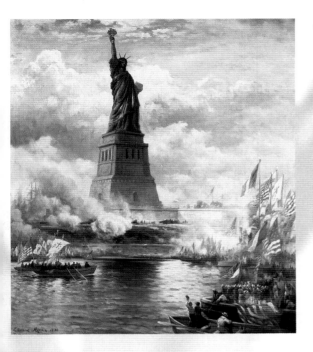

◀ *The Unveiling of the Statue of Liberty, Enlightening the World by Edward Moran, 1886*
The Statue of Liberty was built at the entrance to New York City harbour in 1886. Liberty (freedom) is represented by a woman dressed in flowing robes. She holds a lighted torch in one hand and carries a book with 4 July 1776 (the day America won its independence) written on it in the other hand. Building the statue was an important event in American history. The artist was specially commissioned to paint a picture of the occasion. He has captured the drama of the event, with the boats and waving flags. The statue rises above the smoke from guns fired in celebration.

history

▶ *Living conditions of the unemployed by Dorothea Lange, 1938*
Many artists are interested in the way a photograph freezes a single moment. This photograph was taken at a time when many people in America had no work or money. It records the moment in a poor, crowded home when some food is handed round.

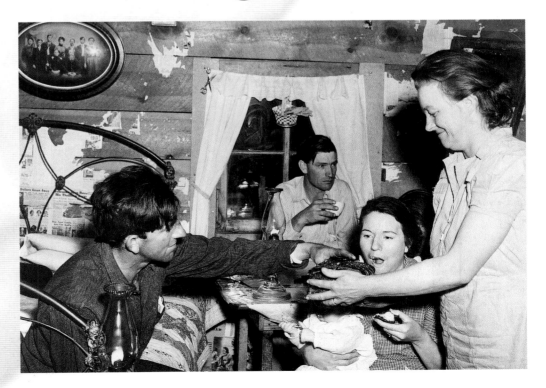

Do you like scary films or books about science fiction or about make-believe places? Maybe you've had strange or wonderful dreams that you want to dream again and again. Some artists capture these feelings in their work.

Feeling dreamy

Many artists take us to imaginary places that exist in myths or legends, or in another world. Some people, such as the Australian Aborigines, make drawings of a dream world because it is part of their religion. Richard Dadd painted an enchanted fairy land that existed only in his mind. In 1919 a doctor called Sigmund Freud wrote a book called *The Interpretation of Dreams*. He said that people's dreams were really about the things that they wished they could have or do. Many people took notice of what Freud said, especially a group of artists called the Surrealists. They were interested in works of art that linked dreams to real life.

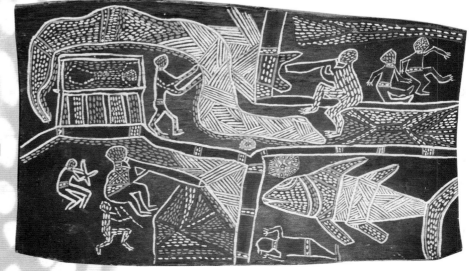

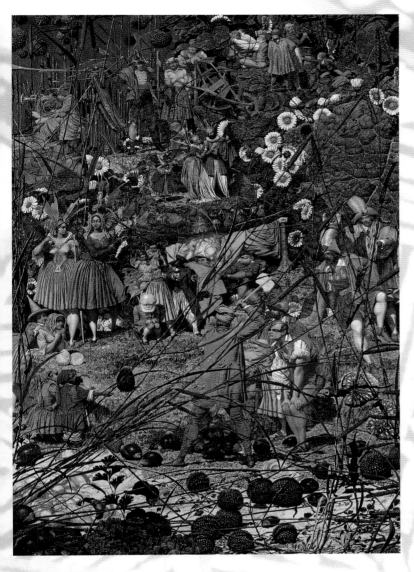

The Fairy Feller's Masterstroke by Richard Dadd, 1855–1864

Richard Dadd took nine years to paint this picture while in prison for murder. Nymphs, elves and other characters gather to watch a fairy woodsman crack a hazelnut. Dadd wrote, 'You can believe all this or not as you choose, since it explains nothing'.

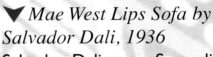

Mae West Lips Sofa by Salvador Dali, 1936

Salvador Dali was a Surrealist. He liked to dream about Mae West, a famous film star of the 1930s. Dali made this sofa modelled on her lips. It is covered in bright red-pink satin.

Aboriginal bark painting

The Australian Aborigines' religion is called Dream Time. It explains how Aborigine lands, plants, animals, birds and people were created thousands of years ago. All Aborigines are descended from the Ancestors, who lived on earth in the Dream Time. This painting made on tree bark shows the path taken by an Aborigine's spirit on its journey to the Next World after death.

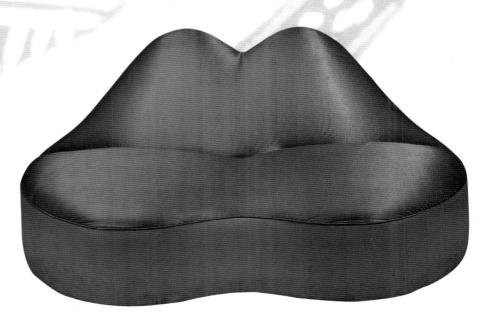

All over the world people like to make themselves look more attractive, to wear nice clothes and make-up. Many people customise their trainers and clothes. Maybe you experiment with hairstyles or wear unusual jewellery?

Looking

From earliest times, men and women have decorated themselves with paint and jewellery to send out a message about themselves to other people. Many ancient people painted their faces to look fierce in battle, as some tribes still do today. Others used tattoos as a way of making themselves look more attractive. Tattoos are still used in this way. Kings, queens and rulers wore precious jewellery to show how important they were. People today still like to wear fashionable jewellery and clothes.

◀ *Queen Nefertiti*
Queen Nefertiti lived in Ancient Egypt more than 3000 years ago. She was famous for her beauty and intelligence. This portrait bust shows her wearing a headdress, jewellery and make-up.

◀ *Henna painted hands, Delhi, India*
Many Hindu and Muslim women pattern their hands with red-brown dye called henna.

▼ *A Fulah woman*
This woman is a member of a nomadic tribe that lives in the Sahara region of West Africa. She wears huge gold and amber decorations in her hair, a nose ring, necklaces, and a patterned scarf and dress.

pretty

◀ *Chinese dragon robe, Qing dynasty, seventeenth to twentieth century*
This picture shows a detail of the embroidery on a beautiful blue silk robe. It is part of traditional Chinese dress. The dragons are a sign of the emperor's power. But Chinese dragons are usually kind-hearted creatures, not the fierce monsters that appear in European paintings.

Do you like messing around with paint, clay or felt-tips? Perhaps you like drawing cartoons to make your friends laugh? Or maybe you prefer to paint happy or silly pictures?

Just for fun

Plenty of artists like having fun too. Pablo Picasso, one of the great painters of the twentieth century, never stopped playing around with materials (see page 26). Some artists have fun playing tricks with images and shapes – now you see it, now you don't. And many like painting pictures of people having a good time. Others draw cartoons to make fun of famous people or those in power, but they are not just for fun. There is often a serious message hidden in the joke.

▶ *Pick 'n Mix by Beryl Cook, 1991* Beryl Cook's paintings look on the funny side of life. She says, 'Pick 'n Mix is one of my favourite occupations, always followed by sit 'n munch as I'm painting or drawing.'

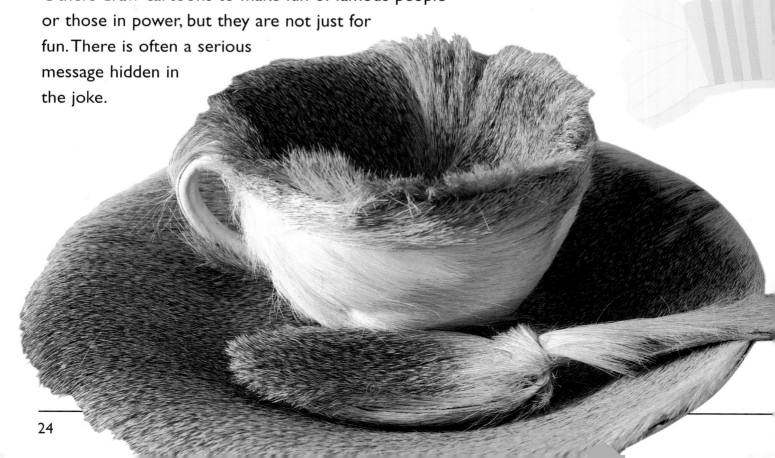

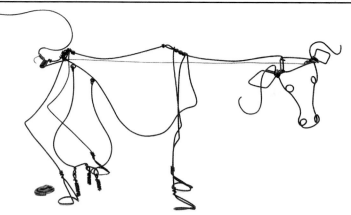

Cow by Alexander Calder, 1929
Alexander Calder loved playing with art – he once made a mini wire circus just for fun. This wire cow has raised its tail to drop a pile of wire cow dung!

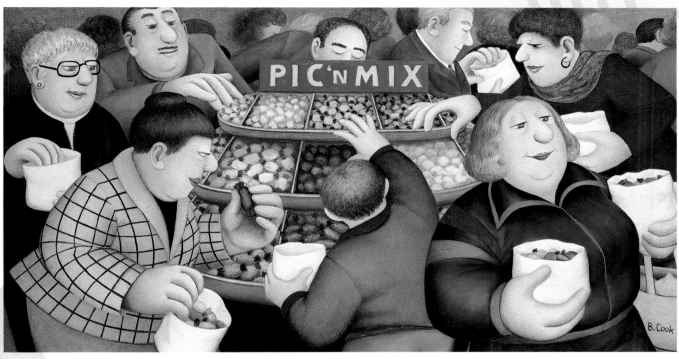

Breakfast in Fur
by Meret Oppenheim, 1936
Meret Oppenheim belonged to a group of artists called Dada that formed just before the First World War. Dada artists said that what was happening around them made no sense, so what would make sense was nonsense! Dada artists made works of art that turned rules upside down.

This fur teacup is a good example – you can't drink from a fur teacup!

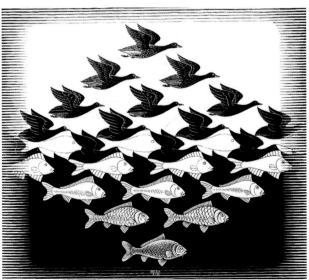

Sky and Water 1 by Maurits Escher, 1938
Escher loved playing around with shapes. Look how the fish gradually change into geese.

In recent times artists have experimented with different materials and ideas, and have questioned what art is for. The pictures and objects they create are very different from earlier art – but is it still art?

But is

Until about 150 years ago most painting showed grand subjects, and sculpture was usually made of expensive materials such as bronze. Today, artists use anything they like to make art. Many are interested in the ideas behind works of art, as well as the finished thing. Marcel Duchamp, a member of the Dada group, questioned why artists have to have skills. In 1917 he put a toilet into an exhibition. Duchamp said it was an example of 'ready-made' art and called it *Fountain*. In the 1970s, one group of artists called themselves Conceptualists (a concept is an idea). They didn't display paintings or sculptures – instead they showed ideas with photographs, tapes, words, video or performance.

◄ *Head of a Bull by Pablo Picasso, 1943*
Picasso, was one of the first artists to question what art is about and to use cheap materials. Here he has made an old bicycle saddle and handlebars into the head of a bull. Do you think it is sculpture?

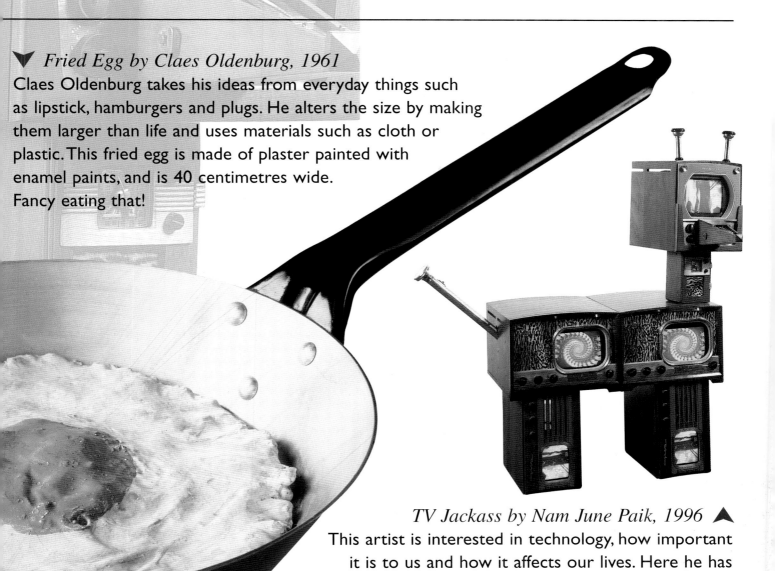

Fried Egg by Claes Oldenburg, 1961
Claes Oldenburg takes his ideas from everyday things such as lipstick, hamburgers and plugs. He alters the size by making them larger than life and uses materials such as cloth or plastic. This fried egg is made of plaster painted with enamel paints, and is 40 centimetres wide.
Fancy eating that!

TV Jackass by Nam June Paik, 1996 ▲
This artist is interested in technology, how important it is to us and how it affects our lives. Here he has used old and new TVs, radios and other equipment to put together this sculpture.

it art?

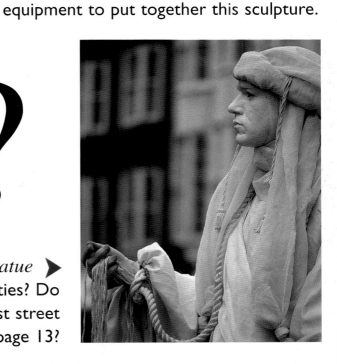

Living statue ▶
Have you seen people posing as statues in cities? Do you think they are performing art, or just street entertainers like the busker on page 13?

About the artists

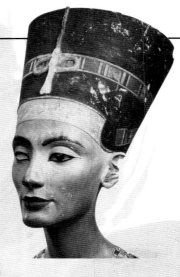

▶ *Fra (Brother) Angelico* was born in Vicchio, Italy, in about 1395 and died in 1455. He lived for most of his life near Florence in Italy where many great artists worked at this time.

▶ *Alexander Calder* was born in Philadelphia, USA, in 1898 and died in 1976. He trained as an engineer and later became a sculptor. Calder is best known for making mobiles.

▶ *Mary Cassatt* was born in Pittsburgh, USA, in 1845 but lived most of her life in Paris, France, where she died in 1926. She was a member of a group of artists called the Impressionists. She liked to paint pictures of her friends and family and of everyday life.

▶ *Beryl Cook* was born in Egham, England. Before becoming an artist she was a showgirl, a model, a shop assistant and a barmaid.

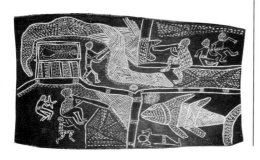

▶ *Richard Dadd* was born in Chatham, England, in 1817 and died in Broadmoor Hospital in 1886. He trained to be an artist at the Royal Academy in London. Later he murdered his father, was found to be mad and was put in a prison for the insane. His family gave him paints, brushes and canvases so that he could carry on painting.

▶ *Salvador Dali* was born in Figueiras, Spain, in 1904. He died in 1989. Dali was a gifted artist and sold his first painting when he was only six! He was expelled from art school for behaving badly and from then on he loved to shock people with his strange behaviour.

▶ *Maurits Escher* was born in Leeumarden, the Netherlands, in 1888 and died in 1972. He was a printmaker who loved to play games with shapes and space and make optical illusions.

▶ *Sir Luke Fildes* was born in Liverpool, England, in 1844 and died in London in 1927. In many of his paintings he showed people living in miserable conditions.

▶ *Georg Forster* was born in Gdansk, Poland, in 1754 and died in Paris, France, in 1794. Forster was better known as a writer, politician and scientist than as an artist.

▶ *Francisco Goya* was born in Saragossa, Spain, in 1746. He died in France in 1828. He painted many portraits of important people. When he was 46 years old he became deaf. From then on he also began to paint pictures that showed his dark thoughts.

▶ *Ando Hiroshige* was born in Edo (now Tokyo), Japan, in 1797 and died there in 1858. He was one of the finest printmakers in the world and famous for painting peaceful, everyday Japanese scenes showing ordinary people.

▶ *Allen Jones* was born in Southampton, England, in 1937 and is a painter, sculptor and a printmaker. He specializes in images of men and women and the feelings between them.

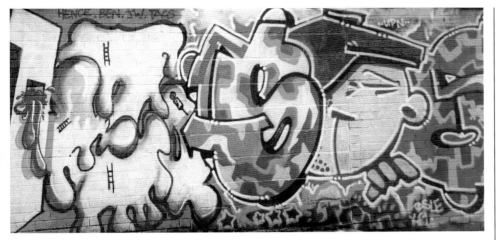

▶ *Dale Kennington* is an American painter. She belongs to a group of painters called photo-realists because their paintings look as 'real' as photographs.

▶ *Oskar Kokoschka* was born in Pochlam, Austria, in 1886 and died in 1980. Hitler thought his paintings were corrupt, so in 1938 Kokoschka moved to England where he painted anti-war paintings during the Second World War.

▶ *Sir Edwin Landseer* was born in London, England, in 1802 and died in 1873. His paintings were first shown in the Royal Academy when he was only twelve. He specialised in paintings of animals.

▶ *Dorothea Lange* was born in Hoboken, USA, in 1895. She died in 1965. Dorothea was a pioneering photographer, well known for her pictures of ordinary people in difficult times.

▶ *Jan Miense Molenaer* was born in Haarlem in the Netherlands about 1610 and died in 1668. He was often in debt but he paid people back with his paintings instead of money. He was also arrested for fighting and for using bad language!

▶ *Edward Moran* was born in England in 1829 and died in 1901. He was one of a family of artists who emigrated to the USA. He painted seascapes and history pictures.

▶ *Edvard Munch* was born in Lote, Norway, in 1863. He died in 1944. Edvard Munch suffered from mental illness. He had many unhappy friendships with women and his paintings are often about his problems with them.

▶ *Claes Oldenburg* was born in Stockholm in Sweden in 1929 and now lives in the USA. He is one of the most important Pop Artists.

▶ *Meret Oppenheim* was born in Berlin, Germany, in 1913. She died in 1985. *Breakfast in Fur* is her most famous work of art. She bought the teacup from a supermarket and covered it with fur from a Chinese gazelle.

▶ *Nam June Paik* was born in Seoul, North Korea, in 1932. He is also a musician and is interested in the links between images and music. He was one of the first artists to use video in his work.

▶ *Pablo Picasso* was born in Malaga, Spain, in 1881 and died in Mougins, France, in 1973. During his long life he started many new artistic movements and worked in many different materials apart from paint, such as pottery, sculpture and printing.

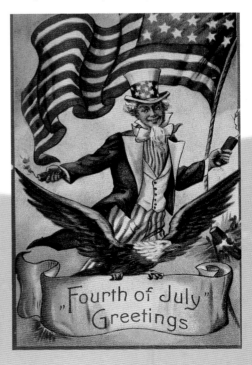

Things to do

Signs and symbols *pages 4–5*
Spot how many signs, symbols and logos you can see in your local high street that give a message. For example, traffic lights warn you to stop and go.

Story without words *pages 6–7*
Draw a short story, using no words at all. Make sure the reader can follow what's happening by looking only at the pictures.

Poster message *pages 14–15*
Draw a poster with a message. Get the message across with what's in the picture as much as by the words.

Feeling moody *pages 16–17*
Paint an angry, calm or spooky picture. Ask your friends how it makes them feel when they look at it.

A piece of history *pages 18–19*
See how many things you can spot in your room which record a particular moment, for example the Millennium.

Funny faces *pages 24–25*
Make a caricature of a friend. Decide what their main features are – spiky hair? A big nose? Spots? Gappy teeth? Now exaggerate them by making them bigger or smaller!

Glossary

archaeologist Someone who studies the past by looking at old objects and ruins.

busker A street musician.

caricature A picture of a person that exaggerates their features to make people laugh.

cartoon In the past it was a trial design or drawing for a painting. Today, it also means a drawing made to make people laugh.

carving Something cut into hard material such as stone or wood.

commission To pay for a work of art to be made.

conceptualist An artist who believes that the ideas behind a work of art are as important as the work of art itself.

customise Something that is changed to suit the owner.

Dada A group of artists who worked from 1914 to 1920. They wanted to change the rules of art and made works of art to shock people.

embroidery Decorative sewing.

etching A print (see print) made by drawing on a wax-covered metal plate. Then it is dipped in acid, inked and put through a printing press.

fresco A picture made by painting on to fresh, damp plaster.

friar A monk who preached about Christianity in towns.

graffiti Words and pictures drawn on walls in public places.

image A picture or likeness of a person or thing.

Impressionist One of a group of artists working in France in the second half of the nineteenth century. They used quick daubs of paint to capture changing light or a passing moment. They were seen as revolutionary and were very unpopular with many people.

jester In the past, someone who was paid to amuse people.

logo A design, in the form of a word or shape, that represents a product or company.

miniature A very small painting, often a portrait.

optical illusion Something that tricks the eye into seeing things falsely.

pastel A type of soft crayon.

Pop Art Art about modern life. It often uses images from comic strips, shopping, advertising and entertainment.

portrait An image of a real person.

portrait bust A sculpture of a person's head and shoulders.

print A picture made by pressing paper on to a hard surface that has been altered by an artist in some way and then inked.

propaganda Information and thoughts to help or to damage governments or groups of people.

reportage Drawing or photographing something as it happens.

sacred Something that is holy.

science fiction Made-up stories about science.

sculptor Someone who creates sculpture.

sculpture A shape made out of solid materials. In the past, sculptures were usually made of stone or valuable metals. Today, artists use all kinds of materials.

shadow puppet A flat puppet that casts a shadow on a screen when light shines from behind it.

shaman Someone who has special powers to heal or call up spirits using medicines or magic.

sketch A quick drawing.

surrealist Surrealists created imaginary scenes. They thought that their dreams and ideas were more real than life. Surreal means 'more than real' from *sur* (the French word for 'on' or 'above') and the word 'real'.

symbol A shape that stands for something else.

tapestry A woven picture made to hang on walls.

totem The special sign of a person, family or tribe.

war artist An artist who is paid to record war scenes.

Index